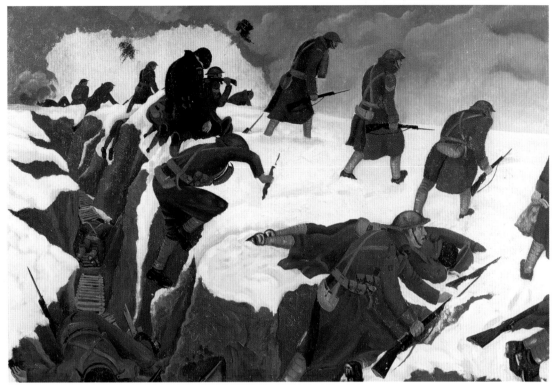

ART
FROM THE
FIRST
WORLD WAR

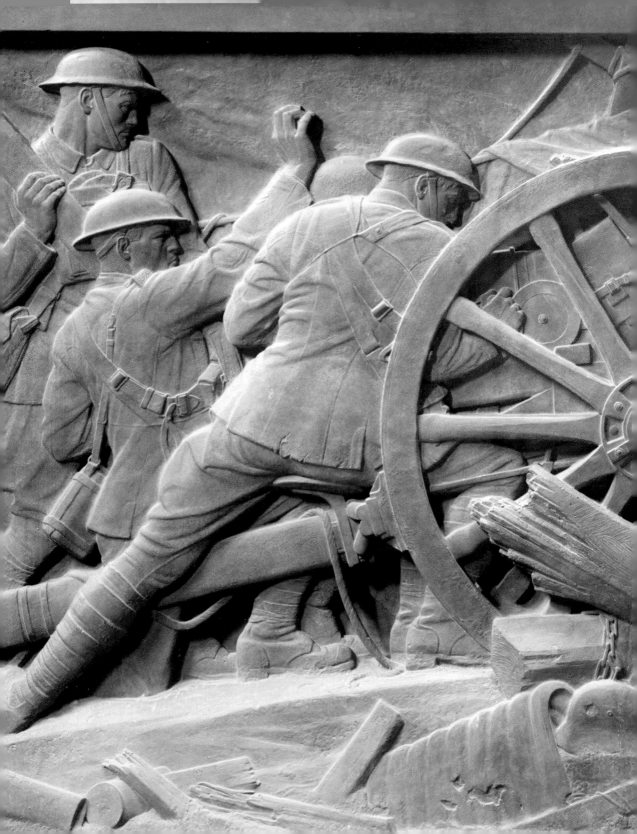

INTRODUCTION

The war art schemes developed by the British government during the First World War were an unprecedented act of government sponsorship of the arts. Initiated to meet the demand for information from a public at home and to sway the opinion of potential allies overseas, the schemes grew in complexity and ambition as the war continued and its impact widened. The first scheme was started by Charles Masterman, then head of propaganda and working under the cover of the British government's nascent propaganda unit, Wellington House. It was intended to produce images for reproduction in books and other publications; in subsequent projects, this broadened out to encompass social history and commemoration. The result of the schemes is IWM's hugely diverse collection in which the art of the radical, younger generation sits alongside that of established society painters. At the core of the programme was a desire to restate the values of British society as liberal and socially inclusive, and not to follow the tradition of battle images of glorious victory, either real or imagined. As a result, disparate and dissident images were commissioned and acquired, but the net effect was to cast Britain as torchbearers of Western European liberal culture.

As the schemes evolved, they would ultimately explore every aspect of conflict, from the immeasurable violence of the Western Front to the hastened social and industrial change it demanded at home. It was a collection that had to reflect the experiences of all those involved, namely the entire nation. Artists such as Paul Nash, CRW Nevinson and Eric Kennington, returning from front line service, brought back a dark and disturbing picture of modern warfare. Their subsequent appointments as official artists alongside the establishment figures of William Orpen, John Singer Sargent and John Lavery were the result of the vision and belief that only artists who had witnessed their subject matter could produce a memorial to match the national sacrifice. Many of the commissions continued long after the war had ended, and by the end of 1920, over 3,500 works had been acquired.

LEFT AND PAGE 1:
Gilbert Ledward RA
18-pdr Gun in Action:
a cast of a panel of the
Guards' Memorial,
St James' Park
(detail)

5

Amongst British artists, before the outbreak of hostilities in 1914, the most cogent and expressive ideas of modern life were associated with the Vorticist artists, and in particular, Percy Wyndham Lewis. Vorticism was influenced by the continental art movements Futurism and Cubism, but developed its own visual language of hard abstraction, with the human form caught in flux and on the edge of a chaotic void. While not all artists adopted this thinking, even those working in more conventional styles were equally influenced by urban life, detailing the subtleties of class and gender in the drawing room, street and theatre. Both were to find their subject matter disturbingly transposed to the battle lines. Lewis's disillusioned belief was that war was embedded into the culture and society of modernity: 'Everything will be arranged for convenience of War. Murder and Destruction is man's fundamental occupation.' Strangely, this avant-garde style, developed to represent and expose the violence and transience of contemporary life, was appropriated in the so-called 'dazzle' designs to camouflage the ships essential for maintaining Britain's supplies and its conduct of the war.

In the first scheme, Muirhead Bone, a Scottish printmaker, was dispatched to the Battle of the Somme in 1916. His images of well-organised and managed efficiency proved to be popular with the public. Even in these strangely reassuring and, at times, prosaic narratives, the undercurrents of transition and transformation which mark the entire collection are visible: the artillery, passively drawn to the front line by horses, emits barrages of unprecedented violence; recaptured towns and villages teeter on the verge of collapse, their architecture riven by shells and mortar; recruits who arrived mobilised and dynamic, return stretchered and disfigured.

Orpen, who was appointed soon after, brought a more emotional and intimate response. Although assured and comfortable around the generals and politicians (he counted Field Marshal Douglas Haig as a personal friend), Orpen found his natural subject in the images of the common soldier. Fascinated with the theatrical, at the Western Front he found a compelling and desperate stage with actors struck dumb and traumatised by the effects of the war. Other, even more stridently confrontational artists followed his appointment. CRW Nevinson and Eric Kennington pictured a soldier's life as relentless and utterly exhausting: men transformed into a component of a large military machine and then spewed out, exhausted, wounded or delirious. In the work of Paul Nash, the combatants are

overwhelmed and dislocated in a landscape driven and shaped by forces beyond their understanding or control. Disenchantment and shock are widespread, loss inevitable. The absence of a visible enemy only serves to compound their sense of powerlessness.

Indeed, the enemy is rarely seen except in shocking moments such as Orpen's *Dead Germans in a Trench*. Instead, we see the violence wrought on the Allied forces and, equally disturbingly, on the landscape. In the traditions of British painting, images of the countryside could be seen as a critique of modern urban life, a restatement of the values lost during industrialisation and, ultimately, as the means to escape from the chains of city life to a romantic rural idyll. However, the war rapidly bridged the distances and differences between urban and rural as citizens, armaments and equipment were carried from the factories and towns along railway lines to the fields of France and Belgium. But, whereas the city, for all its confusion and transience, its spectacle and violence, somehow managed to keep some level of control over social unrest and moral disorder, on the Western Front these forces were all released to shocking effect, defiling the landscape beyond all recognition and removing all possibility that it could be a refuge or a retreat.

Faced with this assault on moral sensibilities, there was an understandable desperation to find signs of redemption, order and morality. These come in the predictable imagery of the stretcher-bearer, the medical orderly, the casualty clearance station, and in the interpretation of deaths of soldiers and civilians as the self-sacrifice of Christ. But there is also a fascination in the entire process of destruction, not just in the individuals caught up in conflict, but right back to the factory. Anna Airy and Flora Lion recorded the hitherto-shrouded details of the shop floor and the contributions made possible through the mechanics of mass production. In their images there is the affirmation that Britain could supply its armies' needs, and the hasty retooling of the Singer sewing factory is a reminder of the new commercial opportunities for industry. They also show the effects of social liberation for the workforce of women, seen in their subjects' confident and joyful independence. Finally, the naked aggression of armament production is strangely redefined as a mothering instinct to protect sons and lovers.

In 1918, the British War Memorials Committee commissioned a series of paintings and sculptures for a proposed Hall of Remembrance to depict all aspects of the war effort. The scheme was initiated by Lord Beaverbrook, British Minister for Information, and followed the scale, ambition and pattern of a programme he had started for the Canadian government. This was the highlight of the official art schemes and in its scope and scale was to match the artistic ambitions of the Renaissance. However, the Hall was never built and this collection, augmented by exceptional gifts from Orpen and Lavery; by the self-financed judicious purchases of Muirhead Bone; by commissions from the Imperial War Museum itself and the final commissioning of Orpen at the Peace Conference, forms the core of IWM's collection. That so much effort and so many artists were recruited is in itself an insight and measure of the national impact of total warfare. Were the artists exploited in their service of the government's agenda, sustaining its approach to the war? Clearly, many felt a sense of duty to respond to the commissions and welcomed the opportunities to support the national cause. That for so many artists, the commissions nurtured their finest work is perhaps a measure of the vision of the schemes and the dedication and skill with which they were managed. Artists were given both support (for many, it was their most important source of income), access and freedom to interpret what they had witnessed. It was as part of the Hall of Remembrance project that Sargent's majestic *Gassed* was created, recording a nation transformed from social ease to uncoordinated, blind staggering. If the legacy of these schemes at times makes for uncomfortable viewing, their documentation of unprecedented times remains an extraordinary testament both to their creators and subjects.

Roger Tolson
IWM

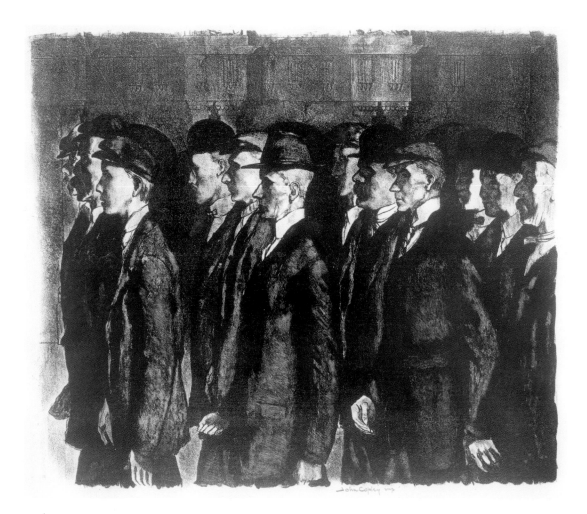

John Copley

Recruits, 1915

lithograph, 51.0 x 66.6 cm

Although Copley trained initially as a painter, it was as a printmaker that he excelled. Working mainly with lithographs and etchings, he had a particular fascination with music hall and theatre subjects. These he often captured with a detached air and mild sardonic humour. *Recruits, 1915* shares these characteristics, showing a motley array of army volunteers answering the nation's call to arms. Unlike Germany and France, Britain did not have universal military service and was reluctant to impose conscription at the beginning of the First World War, hoping instead that the male population would enlist out of a sense of duty and patriotism. Yet, with ever-decreasing numbers of volunteers, in 1916 Britain bowed to the inevitable and introduced conscription.

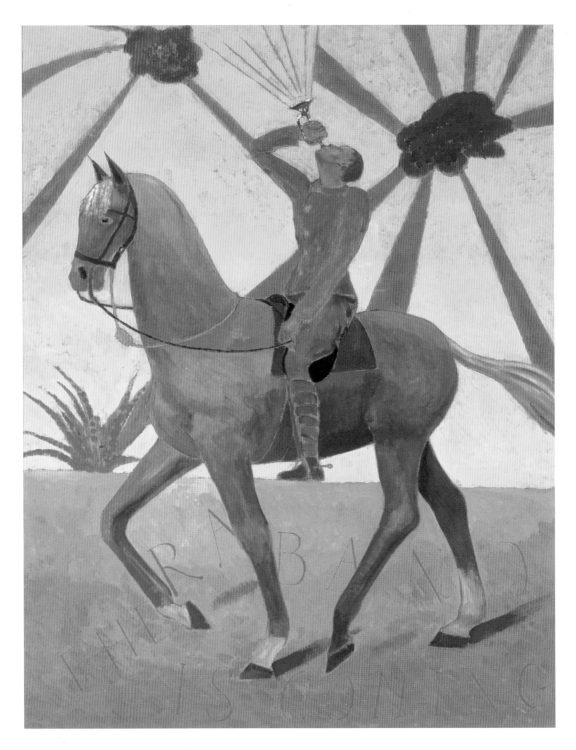

Darsie Japp MC

Regimental Band, c.1918

oil on panel, 91.4 x 71.1 cm
Gift of the artist, 1920

The depiction of the front line as a decorative scene is
strangely disturbing. The explosions must surely drown
the sound of the bugle as the rider crosses a scene of
terror, reduced to a backdrop by its familiarity. This work
was a design for a poster. Japp was also commissioned to
make a work for the Hall of Remembrance.

Colin Gill

Evening, After a Push, 1919

oil on canvas, 76.2 x 50.8 cm

At the outbreak of the First World War, Gill joined the
Royal Garrison Artillery but in 1916 was seconded to the
Royal Engineers to work as a camouflage officer.
He was commissioned to make a major work for the
Hall of Remembrance along with a series of smaller
pieces and returned to France in November 1918, visiting
Mons hours after it had been retaken by the Allies at the
end of hostilities.

'The original line, which the advancing army leaves
behind in its forward movement, remains desolate and
encumbered with the debris of battle.' *Colin Gill*

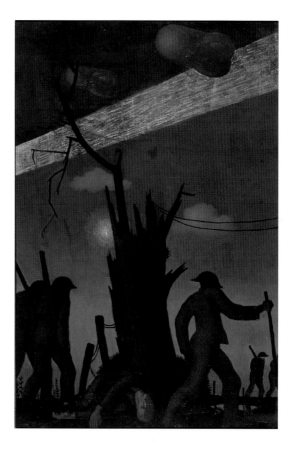

Bernard Meninsky

The Platform Canteen, Victoria Station, 1918

oil on canvas, 50.8 x 76.2 cm

Meninsky had previously served as a private in the Royal Fusiliers before being commissioned by the Ministry of Information in May 1918. The concept of the series *Victoria Station, District Railway* came directly from the Ministry: 'The immediate purpose for which Meninsky is desired is that he should paint important pictures representing typical London scenes during and after the arrival of a Leave Train from the Front'. Meninsky was enthusiastic about this choice, and the painting is one of six he made on this subject. Here, the soldiers pass from light into shadows as they say their farewells and leave for the platforms.

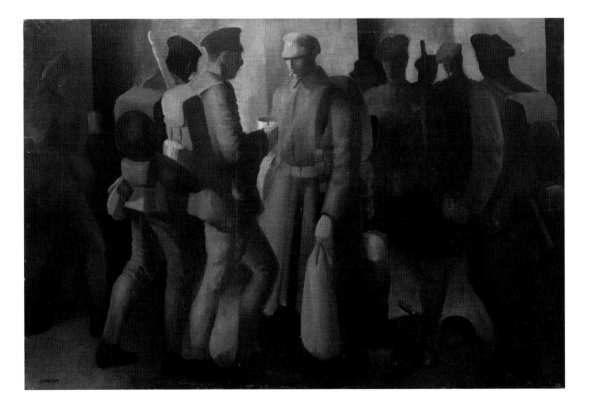

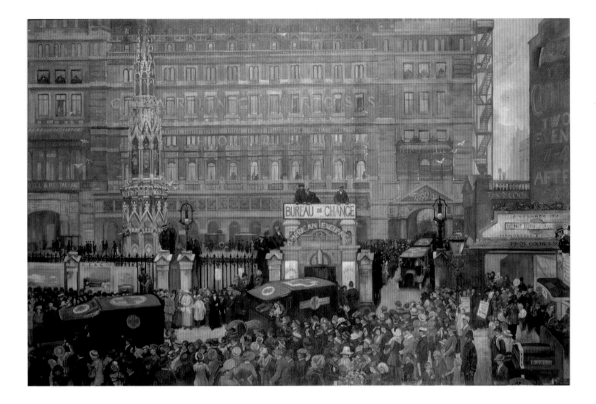

J Hodgson Lobley

Outside Charing Cross Station, July 1916. Casualties from the Battle of the Somme arriving in London, 1918

oil on canvas, 205.7 x 307.3 cm
Gift of the British Red Cross Society and
Order of St John of Jerusalem, 1919

J Hodgson Lobley was an official artist for the Royal Army Medical Corps (RAMC). His painting of the traffic streaming out of Charing Cross station, into the heart of London and the Empire, tells a number of stories. The great facade of the hotel, a symbol of British imperial confidence before the war, watches over the demise of the nation's youth; the Thomas Cook sign is a reminder that the station was once the gateway to Europe; at the bureau de change, the only exchange is that of fit, young men for casualties. Meanwhile, the newspaper vendors hail a woefully optimistic start to the Somme as the crowd welcomes back its heroes. Lobley's interest in the rehabilitation of the wounded from the Somme continued after the war with his paintings at the Queen's Hospital for Facial Injuries, Sidcup.

CRW Nevinson ARA

After a Push, 1917

oil on canvas, 57 x 80 cm

The Road from Arras to Bapaume, 1917

oil on canvas, 60.9 x 45.7 cm

Nevinson initially experienced the First World War as a Red Cross Ambulance driver at the Western Front in 1914, followed by a year serving with the RAMC at General Hospital in Wandsworth. He was discharged due to ill health in 1916 but returned to the front as an official war artist in the summer of 1917, where he witnessed the preparations for the Passchendaele campaign. As the war progressed, Nevinson's style had developed a greater realism, although many, including Imperial War Museum curators, thought it lacked the power of his earlier work.

After A Push depicts a seemingly endless battle-scarred landscape, pockmarked with great water-filled craters. The battle has passed over and all identifying characteristics and traces of life have been obliterated with the exception of the broken trees, which line the horizon, and the exploding shells.

The endless road from Arras to Bapaume (*right*) undulates towards the horizon. The use of strong perspective enhances the emptiness and desolation of the scene: flat, featureless fields, broken trees and grey sky. The viewer joins the quiet passage of military vehicles in the aftermath of a bombardment. The official censors requested that Nevinson repaint the traffic after he originally painted the vehicles on the wrong side of the road.

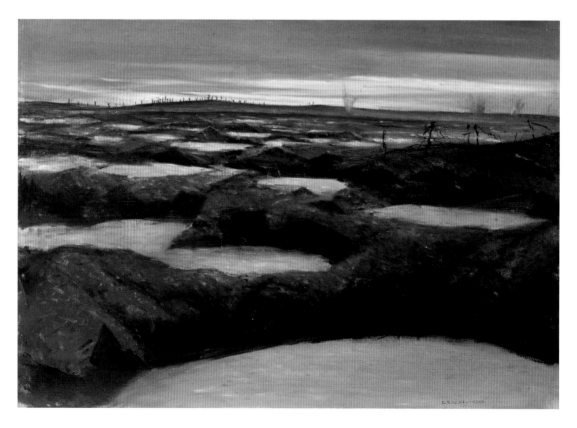

14

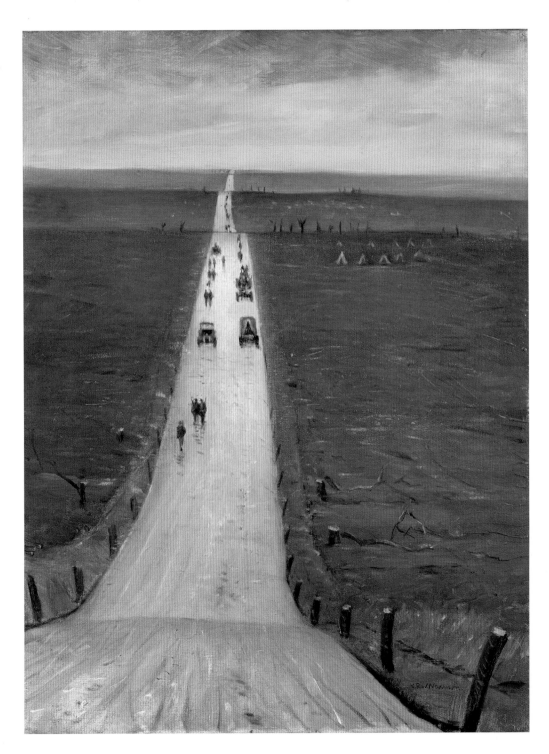

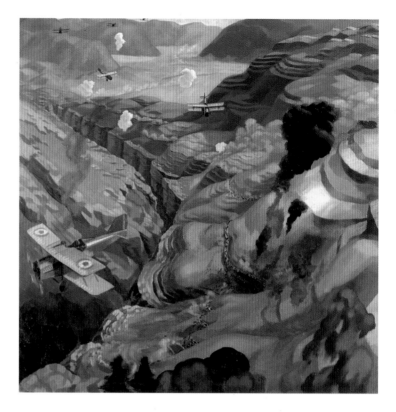

Sydney Carline

The Destruction of the Turkish Transport in the Gorge of the Wadi Fara, Palestine, 1920

oil on canvas, 121.9 x 121.9 cm

'Feb. Friday 14, 1919: Walked along the Wady [sic] Bedan to the Wady Fara – commonly called the Valley of Death – to see the scene of the great aeroplane bombing exploits & the rout of the Turkish army. The road ran along the side of a steep gorge, with precipitous drops down to the Wady runing [sic] below. All along were the debris of overturned carts & motors, & lying every where were the skeletons of horses and even men. Their bones having been cleaned white by the Jackals. It was a dreary tortuous place & the Turkish army trying to escape down it was easily stopped & massacred by aeroplanes. I made a couple of drawings.' *Extract from Sydney Carline's diary, 1919.*

Sydney Carline first trained as a despatch rider before becoming a flyer. He piloted a Sopwith Camel fighter over the Italian front in late 1917. At his brother's request, Sydney was employed as a war artist to paint aerial battles on the Italian front from July to November 1918. In 1919, the brothers were then sent out to work in Palestine and Mesopotamia by the Imperial War Museum, staying well into 1920.

Henry Lamb MC, RA

Irish Troops in the Judaean Hills Surprised by a Turkish Bombardment, 1919

oil on canvas, 183.4 x 219.7 cm

Henry Lamb served as a medical officer with the 5th Battalion, The Royal Inniskilling Fusiliers during the First World War. He was approached with this commission in early 1918, but the War Office was reluctant to release him from active service. Transferred from Palestine to the Western Front, Lamb was then badly gassed shortly before the Armistice. It was only after his demobilisation in March 1919 that he was able to begin the painting. Through the use of an elevated viewpoint, Lamb cleverly highlights the trajectory of the Turkish artillery shells raining down on the Irish soldiers. He also reveals the terror and vulnerability of the men surprised by shellfire on the stony hillside. The painting's style is reminiscent of Stanley Spencer's *Travoys*, one of the few other land battle paintings in the series to depict scenes other than the Western Front.

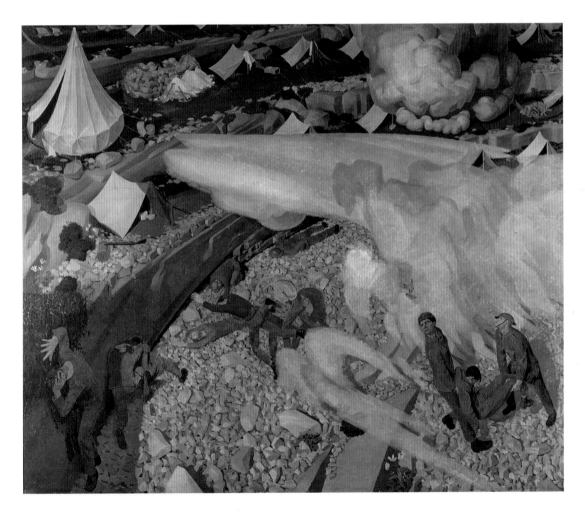

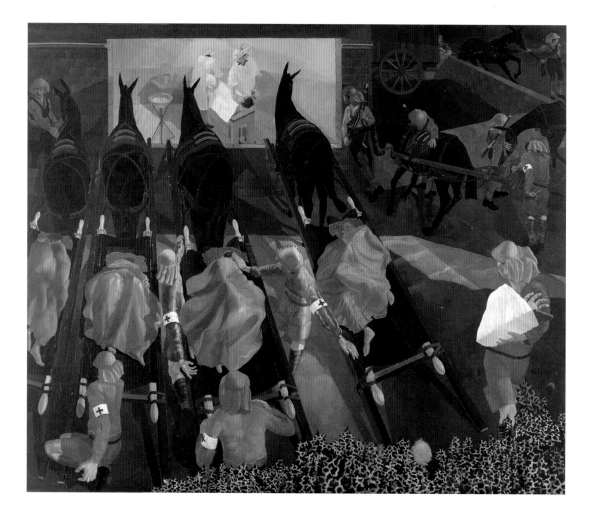

Sir Stanley Spencer RA

Travoys Arriving with Wounded at a Dressing-Station at Smol, Macedonia, September 1916, 1919

oil on canvas, 182.8 x 218.4 cm

This work is based on Spencer's experiences with the 68th Field Ambulance. He wrote: 'About the middle of September 1916 the 22nd Division made an attack on Machine Gun Hill on the Doiran Vardar Sector and held it for a few nights. During these nights the wounded passed through the dressing stations in a never-ending stream. This picture is not in any material or practical sense a truthful representation of the scene it is supposed to depict.'

An old Greek church was used as the dressing station and operating theatre. The wounded were brought down by means of the mule-drawn stretchers shown in the painting. Later, Spencer wrote: 'One would have thought that the scene was a sordid one ... but I felt there was grandeur ... all those wounded men were calm and at peace with everything, so the pain seemed a small thing with them.' The setting, with its human and animal onlookers, recalls the birth of Christ; the calm and stoical medical staff are not just performing a life-saving operation, but are part of a redemptive process.

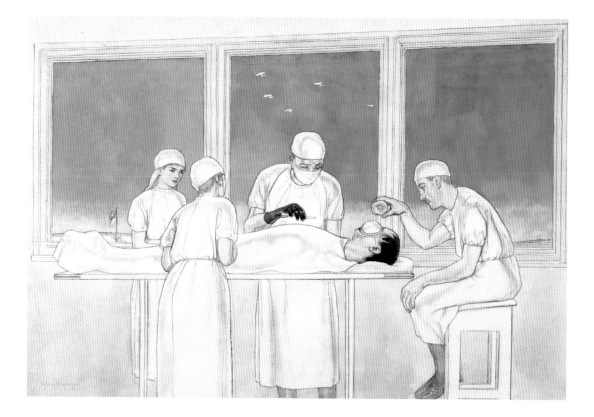

Harold Sandys Williamson

Human Sacrifice: In an Operating Theatre, 1918

pencil, watercolour on paper, 38.1 x 55.8 cm

Williamson trained for a year at the Royal Academy
Schools. Following his second attempt to enlist, he joined
the King's Royal Rifle Corps in January 1916, aged 24.
During recovery from an injury in 1918, he was asked to
undertake some light orderly work in the operating theatre
at No. 6 General Hospital in France. The stark, bright
palette of this drawing is at odds with Williamson's other
more muted war work, perhaps reflecting the pause in the
artist's war. The ambiguous title, the poised stiffness of
the figures and the contrast of the surgeon's sinister black
gloves contribute to a surreal, dream-like image.

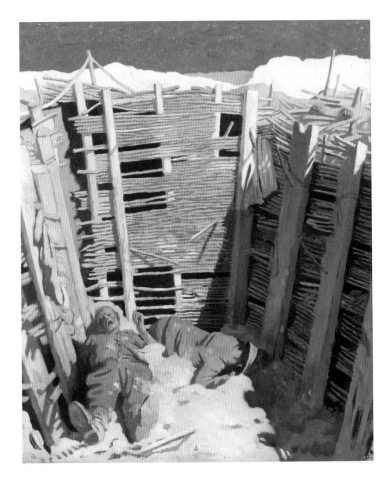

Sir William Orpen RA

Dead Germans in a Trench, 1918

oil on canvas, 91.4 x 76.2 cm
Gift of the artist, 1918

The bright white chalk spoil, immediately behind the wattle-revetted German trench, suggests the Somme Battlefield as the setting for *Dead Germans in a Trench*. The war has moved on, leaving only its derelict victims. The blue-green of the corpse hints at putrefaction and is a marked contrast to the vivid blue of the sky above the parapet. Lurid and disturbing colours appear in several of Orpen's works on the aftermath of battle and clearly reflect his sensitivity to the atmosphere and significance of what he had seen.

Orpen was both one of the first and longest serving of the British war artists. A hugely successful painter in London before the war, he subverted the conventions of the society portrait to paint some of the most disturbing images of the Western Front. He was appointed on army pay only and subsequently gifted his paintings to the museum.

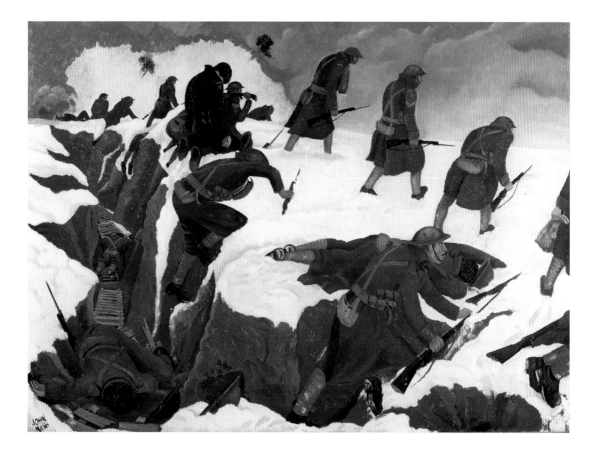

John Nash RA

Over the Top. 1st Artists' Rifles at Marcoing, 30th December 1917, 1918

oil on canvas, 79.8 x 108 cm

Over the Top is one of very few officially commissioned works depicting a specific action. The painting commemorates the involvement of the Artists' Rifles (1/28th Battalion The London Regiment) in an attack on the morning of 30 December 1917 at Welsh Ridge, near Marcoing (south-west of Cambrai). The unit was recalled from 'rest' in response to a German attack and hastily committed to action with inadequate preparation. The consequences were disastrous, and the Rifles suffered heavy casualties. Nash's soldier figures climbing out of the trench, shoulders hunched over, advancing out into the snow, seem resigned to their fate.

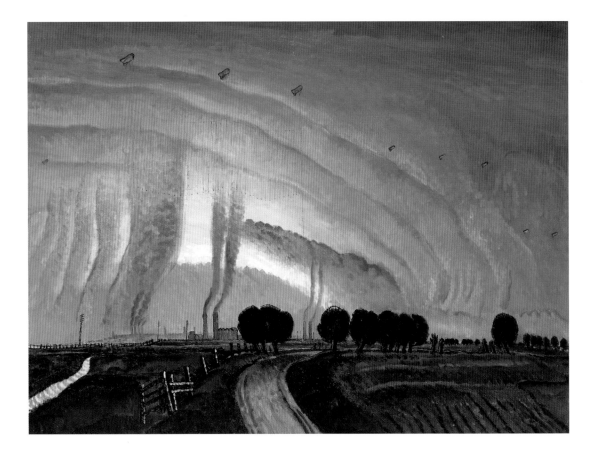

Frank Dobson RA

The Balloon Apron, 1918

oil on canvas, 76.5 x 102 cm

Kynoch's was one the leading suppliers of ammunition and explosives during the war and an obvious target for bombing. The barrage balloon apron screens were intended to force the German Gotha bombers to higher altitude, reducing their effectiveness as bombers and making them more vulnerable to attack. Dobson was suggested to paint the scene. However, problems arose because the Museum's Air Force Committee did not approve of his style, which showed his Vorticist roots. As a result, the idea for a further commission was dropped. An earlier commission with the Ministry of Information had been terminated for similar reasons.

John Nash RA

Oppy Wood 1917. Evening, 1918

oil on canvas, 183.4 x 213.3 cm

John Nash established his name as an artist through his depictions of his experiences on the Western Front. Like his brother, Paul, he served as an infantryman in the 1/28th Battalion The London Regiment. But unlike Paul, John Nash was not formally trained as an artist and became an official war artist in 1918 only after vigorous canvassing by his brother. His artistic output strongly focused on the experiences and minutiae of trench life, particularly front line routines such as the ritual of the dawn and dusk 'stand to'. It is this scene that Nash depicts in *Oppy Wood*, the two soldiers surveying no man's land for enemy action. The wood has been reduced to a collection of tree stumps and the ground to a mass of shell-holes scattered with snow. This destruction is juxtaposed with the beauty of the untouchable blue sky.

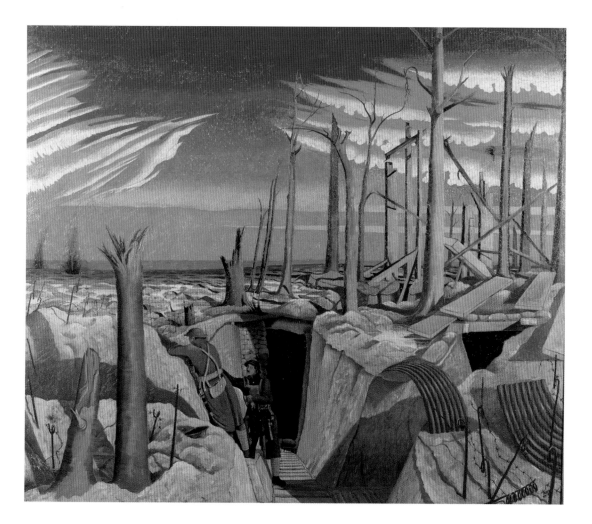

Percy Wyndham Lewis

A Battery Shelled, 1919

oil on canvas, 182.8 x 317.5 cm

Percy Wyndham Lewis was one of the most avant-garde British artists commissioned to complete a large memorial painting. He was a founding member of the Vorticist group, an artistic and literary movement that celebrated the energy and violence of the modern machine age. It was therefore particularly appropriate that Lewis was commissioned as an officer in the Royal Garrison Artillery in March 1916, serving in direct contact with some of the most scientific and destructive weaponry of the war.

Inspired by his experiences on the Western Front, Lewis depicts the effects of counter-battery artillery fire. A British position is bombarded by accurate German fire; the heavily-stylised figures of British gunners perform a frenzied routine as they struggle to move shells to their guns. The three gunners in the foreground appear almost like spectators, their fatalistic and calm detachment reflecting the impersonal nature of artillery warfare.

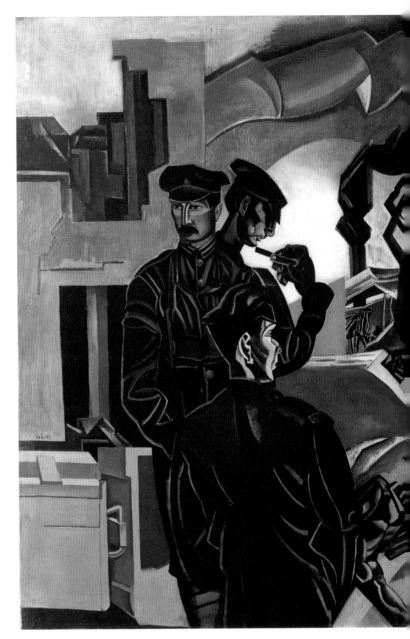

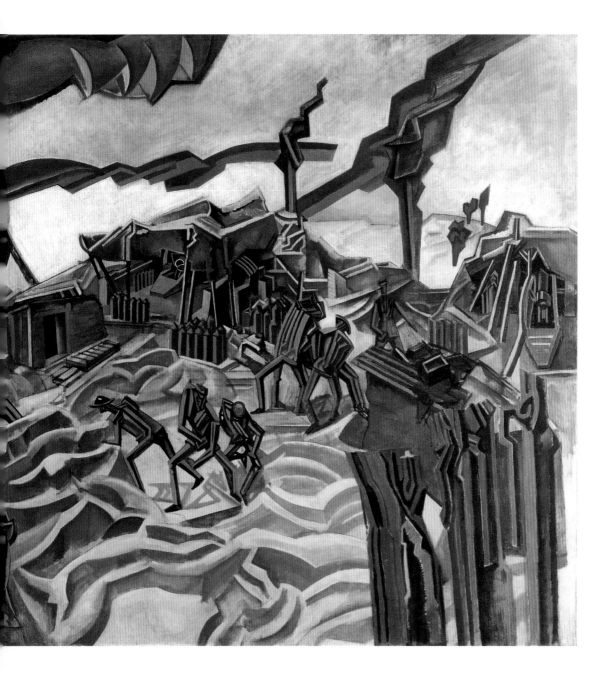

David Bomberg

Sappers at Work: Canadian Tunnelling Company, R14, St Eloi, 1918–19

charcoal on paper, 67.3 x 55.8 cm
Gift of Sir Muirhead Bone, 1919

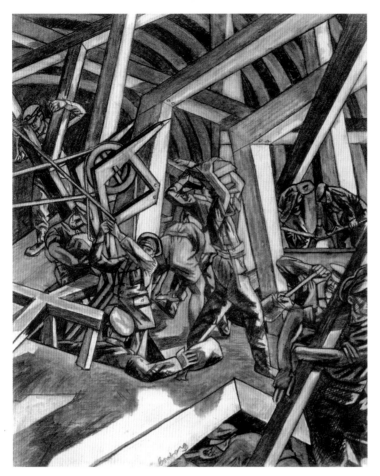

In 1914, the Germans exploded mines under British trenches, initiating mine warfare on the Western Front. In 1918, David Bomberg, then a sapper in the Royal Engineers, gained a Canadian government commission to paint the tunnelling operation at St Eloi, where the largest mine of the war was exploded during the Messines offensive in June 1917. His first painting was rejected as too Futurist, and this study is for a second version, now in the National Gallery of Canada, Ottawa. The complex rhythm of the beams against the curved tunnel walls and the figures' poses remain, both full of tension and kinetic energy, but without the bright colour and bold abstraction. Bomberg shows himself in the foreground, carrying a heavy beam as if burdened by this reworking.

Percy Wyndham Lewis

Officers and Signallers, 1918

ink, watercolour and gouache on paper, 25.4 x 35.6 cm

Officers and Signallers recalls a scene Lewis would have participated in himself. Lewis writes in his autobiography *Blasting and Bombardiering*: 'As a battery officer at the Front my main duties were to mooch about the battery, and to go up before daybreak with a party of signallers to an observation post. This was usually just behind the Front Line trench – in the No Man's Land just behind it.'

The drawing is dominated by contrasts: to the right, officers with their walking sticks are striding purposefully forward. Following to the left, a group of signallers burdened with coiled wire are crouching under the incoming bombardment. The cool, intense greys and blues juxtaposed with the warm ochre and browns used for the landscape emphasises the different mindsets of the officers and signallers.

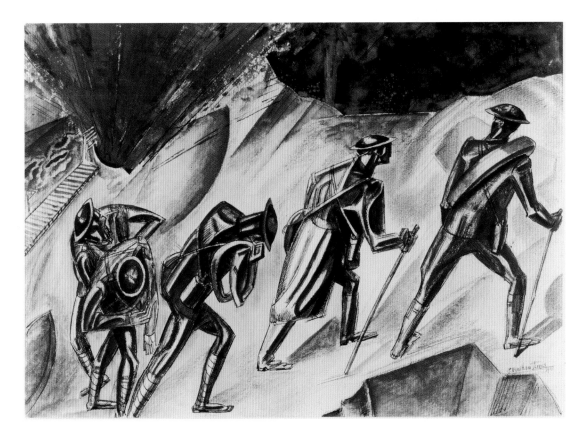

David Jones

Life in the Trenches, c.1936

ink on paper, 33 x 20.4 cm

From 1915, Jones served in the
15th Battalion The Royal Welch
Fusiliers on the Western Front, an
experience that changed his life
and which he later recalled in his
prose-poem *In Parenthesis*, published
in 1937. Jones regarded the war in
epic terms, imbued with religious,
moral and mythic overtones, themes
that flow throughout the poem.
In this drawing, the infantrymen
almost merge into one as they move
along a trench, the narrowness of
the duckboards emphasising their
precariousness as they teeter on the
edge of safety amidst the explosion
of shells.

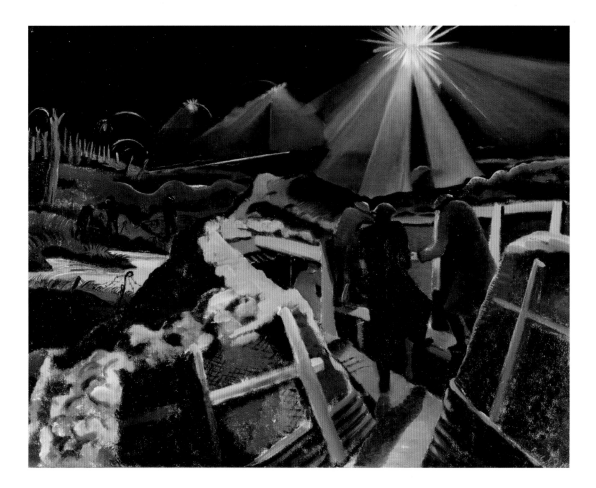

Paul Nash

The Ypres Salient at Night, 1918

oil on panel, 71.4 x 92 cm

A peculiar feature of the Salient was the disorientation experienced by the defenders, caused by the changes in direction of the line; this was often exacerbated at night by the almost-constant discharge of shells, signal rockets and observation flares by both sides. Like an earthquake or boats caught in a storm, the shifting ground hints at this disorientation and deeper disturbances.

The Salient was well known to Nash through his service, and the painting itself is filled with recognisable details. The raised earth walls of the breastwork 'trench' (indicating the presence of surface water in this low-lying area) are supported by frameworks of timber and expanded wire, with a base of curved corrugated iron. The sentries on the fire step keep their heads down in the dazzling light caused by the star shells.

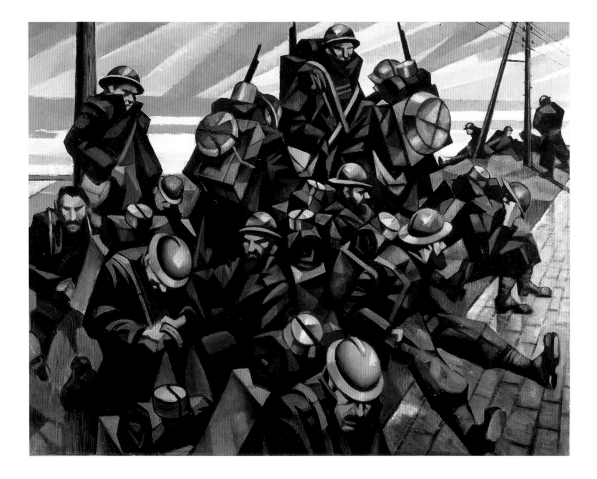

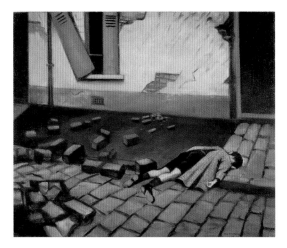

CRW Nevinson ARA

French Troops Resting, 1916

oil on canvas, 71.1 x 91.4 cm
Gift of Fulham Borough Council, 1961

A Taube, 1916

oil on canvas, 63.8 x 76.6 cm
Gift of Sir Alfred Mond, 1917

Nevinson's strong and public pre-war association with Marinetti, leader of the dynamic and aggressive Futurist movement, probably compelled him into service in spite of his poor health. His brief experiences with the Friends Ambulance Unit in northern France and Flanders in 1914 quickly led him to reject Futurism's acclaim for war. However, he did continue to argue that only its visual language could reflect the 'apparent ugliness and dullness of modern warfare'. Nevinson's images of soldiers were immediately received with critical and public acclaim. They are usually tightly framed, and the soldiers, en masse, crudely formed and readily dispensable, are unwitting components of a larger, uncontrollable machine, singularly unaware of its wider purpose. The tension between exhausted individuals with no final destination in sight and compelling force, represented in the driving lines of the landscape, makes this one of the most powerful images of the war.

The *Taube* was primarily a German reconnaissance plane but carried bombs that could be thrown from the cockpit. Up to 1916, nearly all German planes were described as *Taubes*, whether they were or not and the actual type of plane responsible for this attack may not have been one. Nevinson emphasises the increasing vulnerability of the civilian population during the First World War through an evocation of casual violence. In his autobiography, *Paint and Prejudice*, Nevinson describes the scene: 'Dunkirk was one of the first towns to suffer aerial bombardment, and I was one of the first men to see a child who had been killed by it. There the small boy lay before me, a symbol of all that was to come.' As war demanded the efforts of entire nations and as the technology of the First World War developed, almost any target could be hit and its legitimacy justified. Judgement is not specifically against the individual pilots but against the means and methods of war.

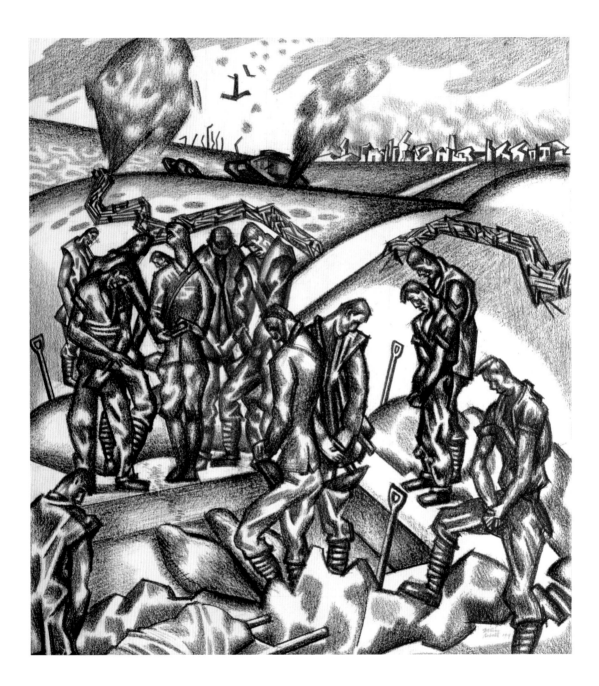

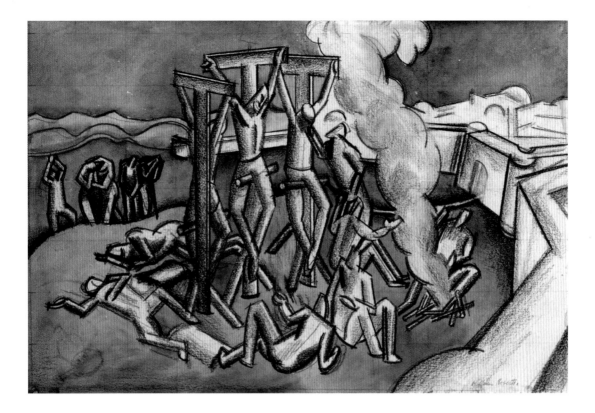

William Roberts RA

Burying the Dead After a Battle, 1919

black crayon on paper, 60.2 x 55.5 cm

Study for 'Crucifixion', 1922

chalk, watercolour on paper, 18 x 22 cm

Roberts had been a member of the avant-garde Vorticist group before the war and a soldier-artist during it. While serving in the Royal Field Artillery, he produced a large painting and numerous drawings and watercolours depicting the life of a gunner in a modernist style that was eminently suited to the subject. After 1918, though no longer a war artist, he continued to make work that reflected his wartime experiences. He used the same harsh, abstract style with its implied critique of the dehumanising effect of war on the men who fought.

Burying the Dead After a Battle is a particularly bleak and ferocious image, seemingly devoid of compassion and empathy. Amidst the general carnage and destruction – shells exploding randomly, houses reduced to abstract ruins, an aeroplane diving or falling through the sky – human existence has lost its meaning. The dead are too numerous and no longer retain their individuality. The soldiers are not performing a sacred rite but carrying out a necessary duty.

In the *Study for 'Crucifixion'* (*above*), Roberts revisits the same landscape but with roles reversed: the living are now crucified and the dead are the soldiers scattered around the feet of the crosses, gambling and taunting. The indicators of life and death have become blurred by the war and its aftermath.

33

Paul Nash

The Menin Road, 1919

oil on canvas, 182.8 x 317.5 cm

In early 1918, Nash was commissioned to paint a Flanders battlefield for the Hall of Remembrance. Nash depicted an area known as 'Tower Hamlets' near the Belgian village of Gheluvelt, one of the most battle-scarred areas of the Ypres Salient. He began working in a barn studio near Chalfont St Peter in Buckinghamshire: 'How difficult it is ... to put [the luxuriant green country] aside and brood on those wasted in Flanders, the torments, the cruelty & terror of this war. Well it is on these I brood for it seems the only justification of what I do now – if I can rob the war of the last shred of glory, the last shine of glamour.'

The maze-like quality of the landscape, transcribed by the erratic patterns of flooded trenches, creates a sense of deliberate disorder and chaotic immorality in which perceptions and expectations are upturned and the rules of the game unknowable. The road itself is devastated beyond recognition; explosions replace natural forms, bursts of sunlight become gun barrels and the reflections of trees resemble iron columns.

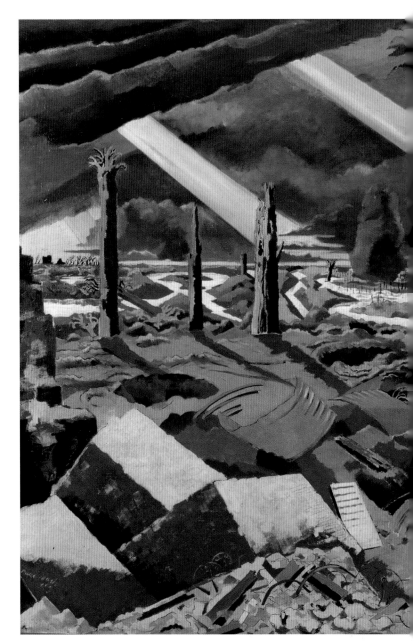

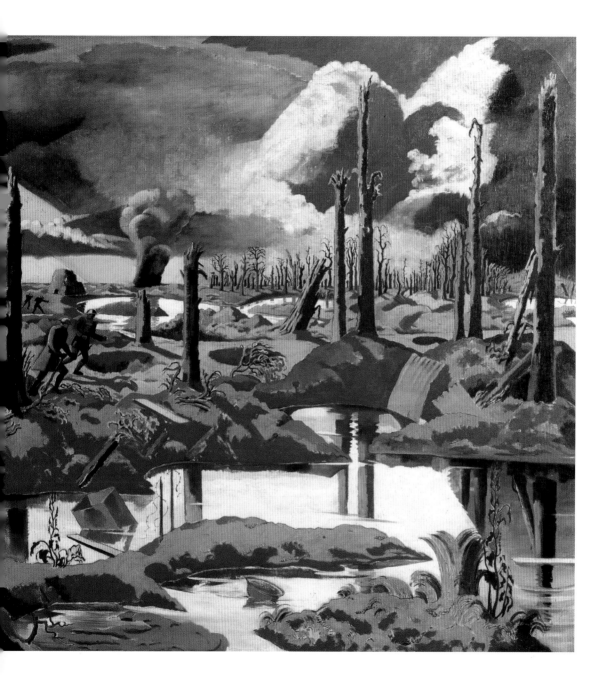

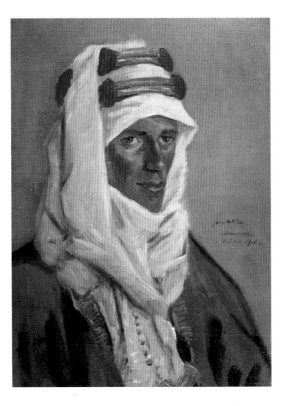

James McBey

Lieutenant-Colonel T E Lawrence CB DSO, 1918

oil on canvas, 53.3 x 38.1 cm

McBey's reputation as an established printmaker who had travelled to North Africa in 1911 made him an outstanding choice to record military life in Egypt in 1917. He later followed the Allied advance through Palestine from Gaza to Damascus. He worked mainly in watercolour but began to use oils as the climate improved, and turned from landscape to portraiture, painting Allied leaders.

In Damascus McBey drew Emir Sherif Feisal and the headquarters of his Hejaz army, and also took the opportunity to paint TE Lawrence, then rapidly becoming a celebrity following his successful co-ordination of the Hejaz against the Turkish forces.

Sir William Orpen RA

Ready to Start. Self Portrait, 1917

oil on panel, 60.8 x 49.4 cm
Gift of the artist, 1918

Painted shortly after his arrival in France, Orpen is inspecting himself in the mirror while wearing military uniform. In a wonderfully revealing self-portrait, he sets out an artistic agenda of colour, pattern, light and texture, and a social agenda of drink and sensuality that were to be fulfilled during his time in France.

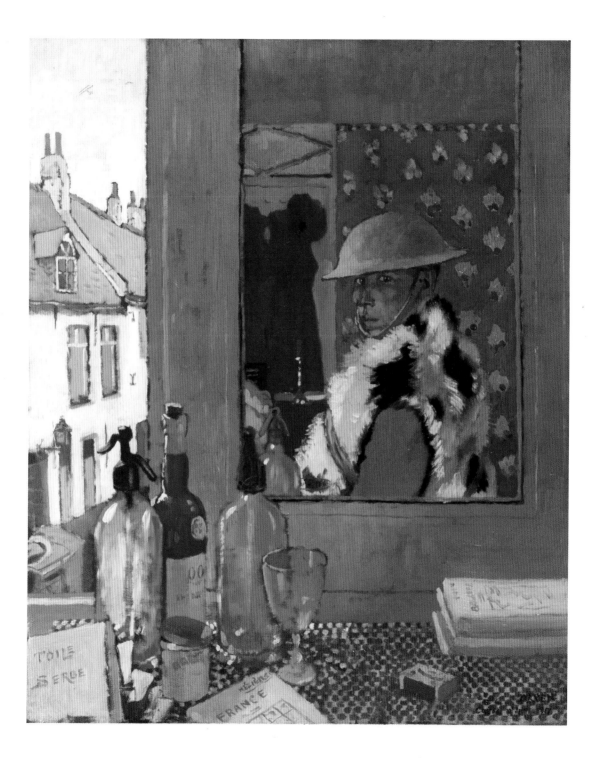

Sir Jacob Epstein

An American Soldier, 1917

bronze, 40.5 x 26.5 x 28.2 cm
Gift of Sir Muirhead Bone, 1919

Having offended public sensibilities before the war with his major sculpture commissions, efforts to employ Epstein by the Imperial War Museum and the Ministry of Information were twice thwarted. A third commission was allowed to fall by the wayside and a fourth publicly denied. Epstein had started to make portrait sculpture of soldiers before joining the Royal Fusiliers in 1917.

Sir William Orpen RA

A Man with a Cigarette, 1917

black chalk, pencil, watercolour on paper,
58.4 x 44.4 cm
Gift of the artist, 1918

Orpen had great empathy with the
serving soldiers, and his images of
them shell-shocked and traumatised
are among some of the most moving
from the First World War. They
emerge from the battle scene as
nameless actors who have lost their
lines, caught in the glare of the
footlights and unable to step off
stage. Orpen had a fascination with
the theatrical, both in his own self-
portraits and in set-piece works he
created before the war.

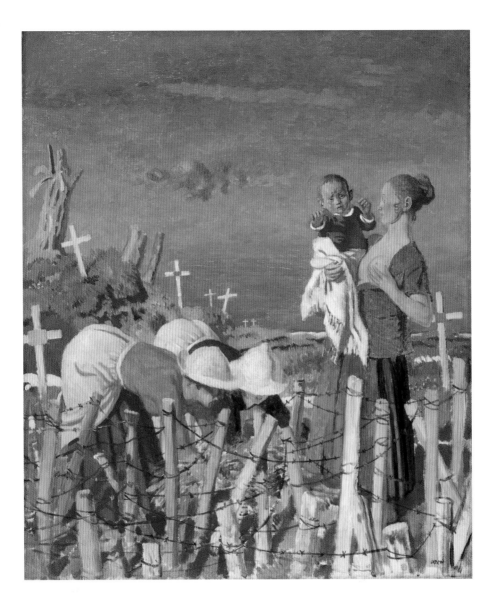

Sir William Orpen RA

Harvest, 1918

oil on canvas, 76.2 x 63.5 cm
Gift of the artist, 1930

For *Harvest* Orpen abandoned his palette of pastel colours for something more garish, perhaps attributable to the artist's slight colour blindness, but which helps to convey the unreal nature of the war. The women leaning towards the ground as if harvesting are actually tending a grave covered in barbed wire – an obscene harvest of battle.

Sir George Clausen RA

Youth Mourning, 1916

oil on canvas, 91.4 x 91.4 cm

Clausen was an established Royal Academician and influential teacher when he painted *Youth Mourning* in 1916 at the age of 64. It represents his personal reaction to the loss of one in ten young British soldiers during the First World War, and particularly to the death of the fiancé of his daughter Katharine.

This allegorical work is unusual in the context of IWM's more representational First World War art collection. It combines traditional classicism and Christian symbolism with the starkly new landscape of the Western Front. Youth, as a vulnerable and distressed young woman, mourns the death of her love, and by extension, the deaths of all young soldiers. The desolate landscape in the aftermath of battle echoes the hopeless abandonment of the hunched figure.

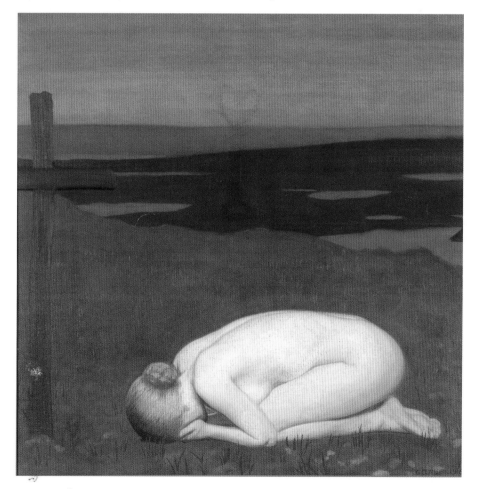

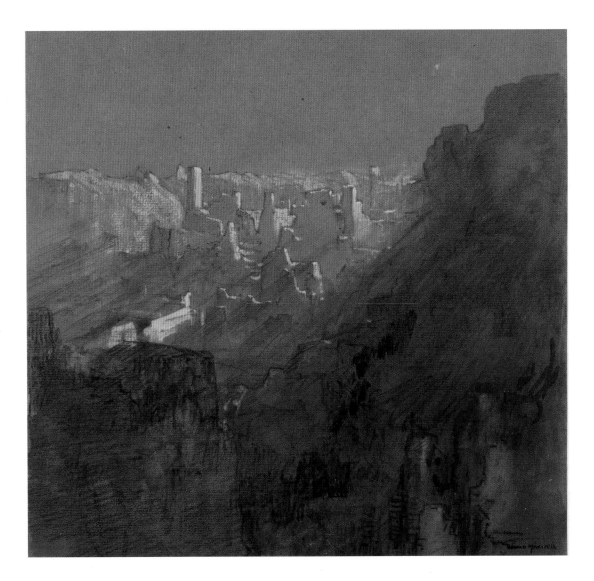

Donald Maxwell

Babylon, 1919

chalk, watercolour on paper, 27.9 x 29.2 cm

Donald Maxwell was commissioned in 1918 to document the activities of British naval forces in the Middle East. This journey resulted in over 100 drawings, which were used to illustrate lively accounts of his travels.

In his book, *A Dweller in Mesopotamia*, he commented on contemporary naval activities along the Tigris at Basra and Baghdad, while also being deeply aware of the ancient history of the area, referring to it as the original 'Garden of Eden'. Maxwell's evocative drawing of the ruined mounds of Babylon conveys the awe experienced by British troops confronted with evidence of such antiquity.

Paul Nash

We are Making a New World, 1918

oil on canvas, 71.1 x 91.4 cm

We are Making a New World is one of the most memorable images of the First World War. The setting is Inverness Copse, the scene of great German resistance during the British offensive of summer 1917, or the Battle of Third Ypres. The title mocks any ambitions of war, as the sun rises on a scene of total destruction. The landscape has become un-navigable, unrecognisable and utterly barren; the mounds of earth are gravestones to a recently-departed world.

At the outbreak of the First World War, Paul Nash joined the army and saw active service in the Ypres Salient, Belgium, until invalided out in 1917. He was subsequently commissioned as an official war artist and returned to the Western Front in late 1917.

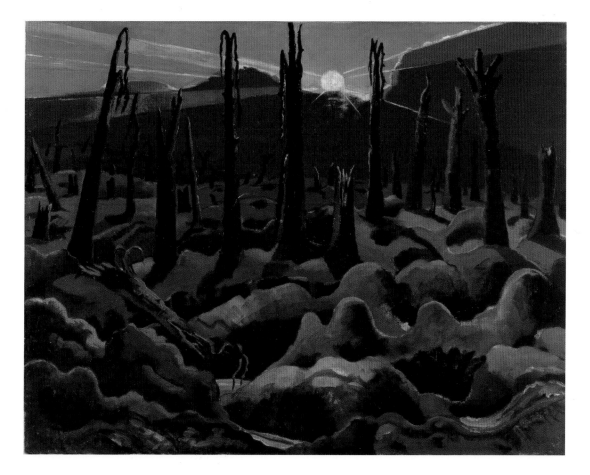

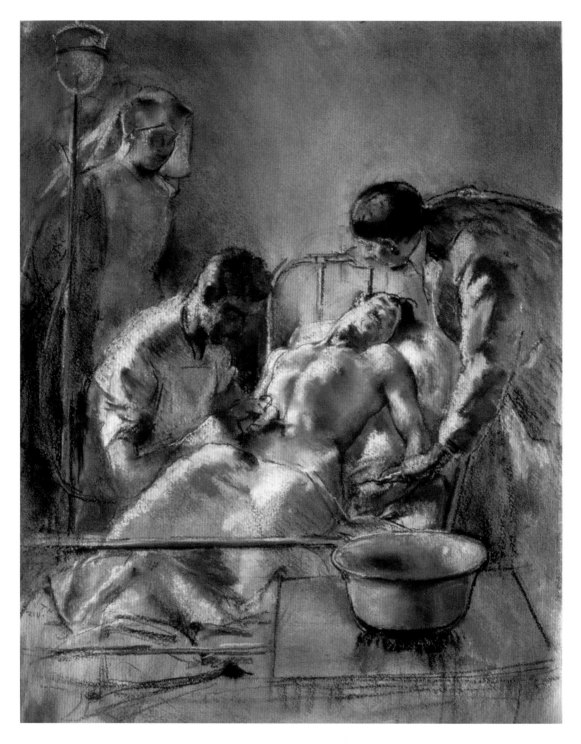

44

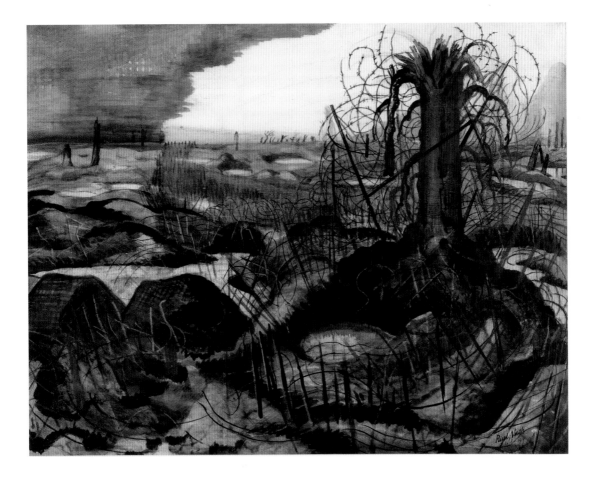

Henry Tonks

Saline Infusion: An incident in the British Red Cross Hospital, Arc-en-Barrois, 1915

pastel on paper, 67.9 x 52 cm

Henry Tonks was a surgeon before becoming an established artist and teacher at the Slade School of Art. During the war he served as a RAMC doctor and worked with Sir Harold Gillies, one of the pioneers of plastic surgery. Tonks drew studies of facial injuries before and after surgery, requiring accuracy, attention to detail and emotional understanding. These qualities are evident in *Saline Infusion*, where the pain of the patient is transmitted through the precisely-rendered tautness of his upper body. The delicacy of the pastel medium, which reflects the mute compassion of the medical staff, contrasts with the hard tension in the man's muscles.

Paul Nash

Wire, 1919

ink, chalk, watercolour on paper, 48.2 x 63.1 cm

Initially titled *Wire – The Hindenburg Line*, this drawing was originally produced in preparation for a lithograph. Here, as in many of Nash's works of the period, the fortifications and the destruction of nature become metaphors for the horror of war. Nash spoke of the destruction of nature as a way for man to begin to comprehend the catastrophe of war. The tree, taking on an almost corporal presence, is a black explosion bursting from the ground, choked by the barbed wire wrapped around its trunk. The spectre obstructs the horizon as the sky above becomes ominously darker.

45

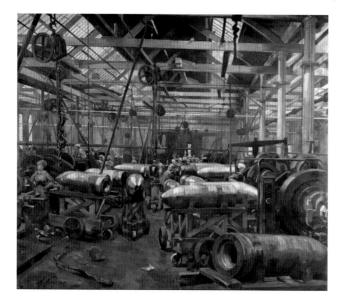

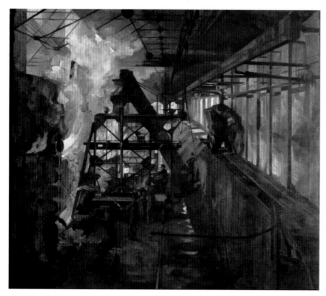

Anna Airy

Shop for Machining 15-inch Shells: Singer Manufacturing Company, Clydebank, Glasgow, 1918

oil on canvas, 182.8 x 213.3 cm

Women Working in a Gas Retort House: South Metropolitan Gas Company, London, 1918

oil on canvas, 184.7 x 217.1 cm

Anna Airy was commissioned to produce four paintings depicting munitions production at a crucial stage in the First World War when the tactical use of heavy artillery had become central to the success of the Allied forces. The success of Scottish heavy industry was built on low investment and cheap labour, and Anna Airy gives some indications of this – the handling equipment is basic and the production lines disorganised. Indeed, workers at the Singer factory had held a major strike in 1911, their grievances encapsulated in the slogan: 'An injury to one is an injury to all'. These paintings measure how far the war economy had developed and society changed: a household name in domestic appliances was now producing armaments, and women, who might previously have been employed in domestic service, were now on the factory floor.

Airy was a contemporary of William Orpen and Augustus John. She was one of the first women war artists, employed by the newly-founded Imperial War Museum in 1918. Although a well-respected female artist of her generation, strict terms were imposed on her contract of employment, which included the right to refuse a work without payment. However, she successfully painted four large works for the Sub-Committee, for which she was paid £280 each. Airy's determination and adventurous spirit also prepared her for the difficult conditions she had to paint under inside the factories.

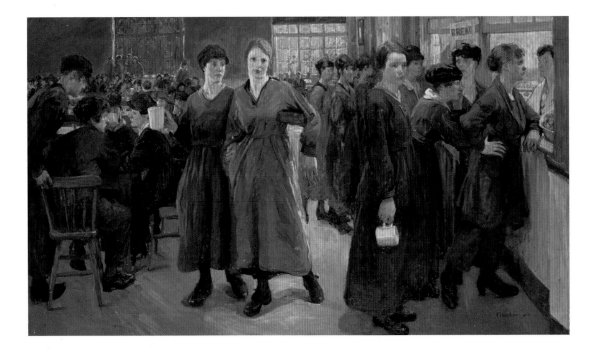

Flora Lion

Women's Canteen at Phoenix Works, Bradford, 1918

oil on canvas, 106.6 x 182.8 cm
Gift of the artist, 1927

Flora Lion was a portrait painter who was given access to paint factory scenes in Leeds and Bradford during the First World War. The interior of the canteen is filled with women workers sitting, chatting and queuing for food. Many are obviously tired. The couple in the centre, arms entwined, dominates the scene and embodies the confidence of women newly liberated by employment.

During the transitional period between the Ministry of Information and the Imperial War Museum, the Ministry was unable to purchase the works. They were eventually donated to the museum in 1927.

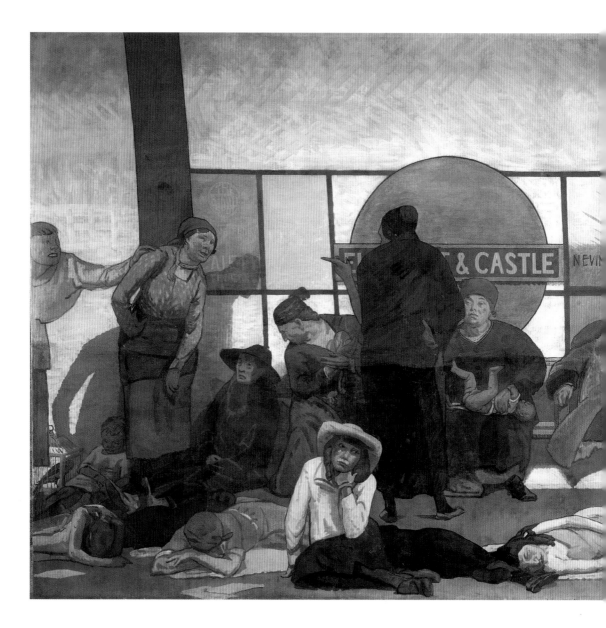

Walter Bayes

**The Underworld: Taking Cover in a Tube Station
During a London Air Raid, 1918**

oil on canvas, 2540 x 5486 cm

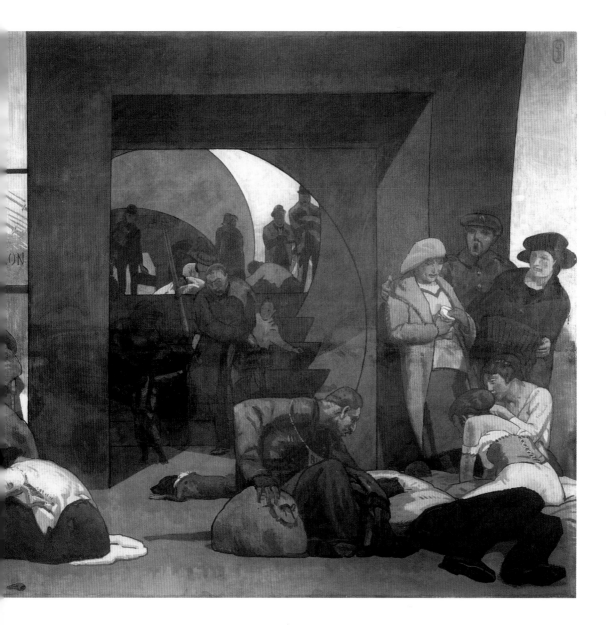

Attacks by German Gotha bombers had started in June 1917, with Londoners seeking shelter in the Tube stations. During the war, Bayes was teaching at Camberwell School of Art, close to the Elephant and Castle, and this was a scene he might have witnessed.

Bayes was a theatre designer and this is apparent both in his use of canvas theatre flats and in the staging of the figures. Passing through the station as if on a train, the viewer is witness to a cast of characters acting out a range of activities, from cheery singing to nursing the sick and resting weary feet.

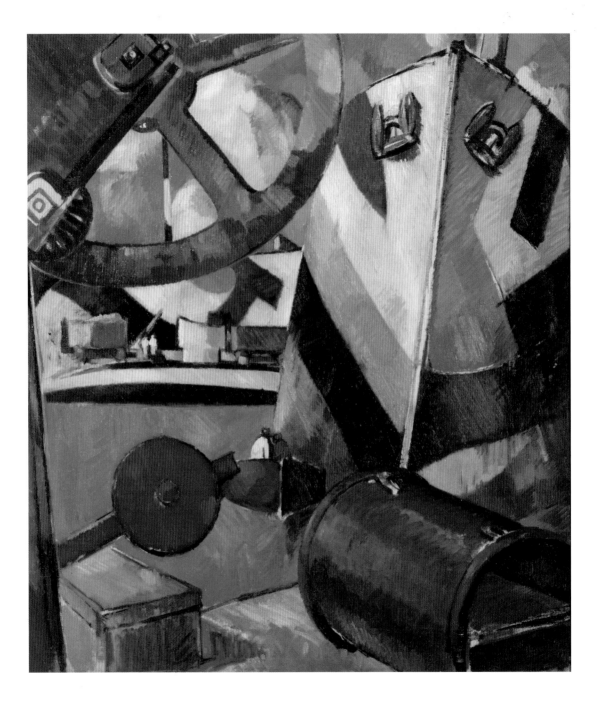

JD Fergusson RBA

Dockyard, Portsmouth, 1918

oil on canvas, 77 x 68.8 cm

Dazzle marine camouflage transformed the look of British dockyards during the First World War. Fergusson was not the only artist to be struck by the dynamic mixture of bright colour and abstract shapes which replaced the sober greys of much pre-war shipping. His painting is a celebration of this unusual aspect of the docks, and his work is much more involved with the formal concerns of shape and colour than with the wartime setting. The painting is dominated by massive machinery, given scale by the small figures in the dinghy and on the far dockside.

The painting plays with our perceptions, moving from the shiny, tangible three-dimensional cylinder to the flat colour and abstract shape of the red 'lever'. It also plays with our ability to perceive depth and form in the same way that dazzle camouflage was designed to distort perception of a vessel at sea.

Edward Wadsworth

In Dry Dock, 1918

woodcut, 12.7 x 21.6 cm

Wadsworth was a key member of the Vorticists with Wyndham Lewis, and his work from this period explored the industrialised machine age in bold, geometric compositions. During the war he served as a naval dock officer supervising the dazzle camouflage painting of ships. The geometric shapes painted on these industrial megaliths were perfectly suited to Wadworth's style and interests. Here, he extends the visual confusion, using solid blocks to merge and dissolve the painted sections of the ship into the surrounding dry-dock.

Geoffrey Allfree

A Torpedoed Tramp Steamer off the Longships, Cornwall, 1918

oil on canvas, 45.7 x 60.9 cm

Allfree created this striking canvas after taking leave on the Cornish coast in 1917. The wrecked vessel's dazzle camouflage, having proved no protection against German submarines, merely adds to the drama of the scene. Allfree, a lieutenant in the Royal Naval Volunteer Reserve and in command of a motor launch, had experienced the Gallipoli campaign before being appointed by the Imperial War Museum's Admiralty art scheme in 1917.

Retaining his command, Allfree attempted to fulfil his commission on a part-time basis. It proved a frustrating arrangement and writing to the scheme's commissioning officer, Commander Walcott, he admitted: 'If I have not done so much as I should have wished or so much as others of the official painters may have done, it is because I have been considerably handicapped by my other duties.' Ironically, the Cornish coast was the setting for Allfree's own demise, drowning in 1918 when the *Mary Rose* struck rocks off St Ives.

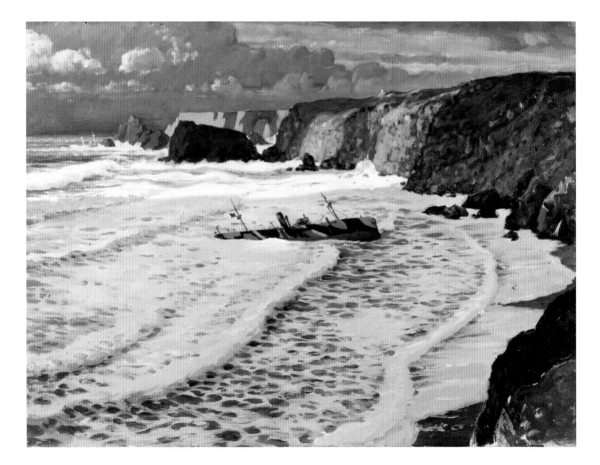

Charles Pears

HMS Fearless, 1918

oil on canvas, 106.6 x 177.8 cm

Prior to the First World War, Pears had mastered technical illustration, contributing maritime subjects for illustrated periodicals such as the *Graphic* and *Illustrated London News*. His reputation for meticulous attention to detail made him an ideal appointment for the Imperial War Museum's Admiralty art scheme with its emphasis on accurate pictorial 'records' of war. In his painting of the cruiser HMS *Fearless*, Pears captures in full the disorientating effects of dazzle ship camouflage, with the vessel painted with a false bow and stern. Dazzle was intended to confuse German submariners when aiming torpedoes, and though Pears was specially commissioned to paint a series of 'dazzled' Royal Navy warships, the camouflage scheme was more usually applied to Britain's vulnerable merchant fleet.

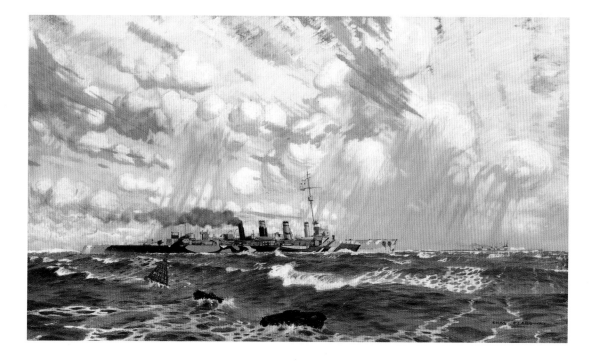

Eric Kennington
RA

Gassed and Wounded, 1918

oil on canvas, 71.1 x 91.4 cm
Gift of the artist, 1934

RIGHT:

The Kensingtons at Laventie, 1915

oil on glass, 1397 x 1524 cm

Gassed and Wounded is based on drawings made at a casualty clearing station near Peronne, France, during March 1918, just as the Germans were bombarding the British lines as a prelude to their last big offensive. Kennington was appointed an official war artist in August 1917 and stayed in France until March 1918. The painting powerfully conveys the cramped conditions and darkness of the station. Wounded soldiers rest cheek by jowl, and the shadowed figure of one of the orderlies dominates the foreground, forming an unusual focal point.

Kennington had served in the 13th Battalion The London Regiment, popularly known as 'The Kensingtons', from 1914 until June 1915, experiencing front line duties during the bitterly cold first winter of the war. The painting (right) depicts men in his unit, No. 7 Platoon, 'C' Company, and includes a self-portrait. He shows a moment when his platoon, exhausted from four sleepless days and nights in the snow and frost-covered trenches, have made their way through the deep mud of a communications trench to the comparative protection of a ruined village at Laventie. The men are waiting for their corporal to give the order to 'fall in' for the next part of the journey: a march of five miles to a billet outside the shelling area.

The painting is a reverse painting on glass, with the exterior layers of paint applied first, which gives the oils a particular clarity. The complexity of the composition and technique caused Kennington to claim he had 'travelled some 500 miles while painting the picture on the back of the glass, dodging round to the front to see all.'

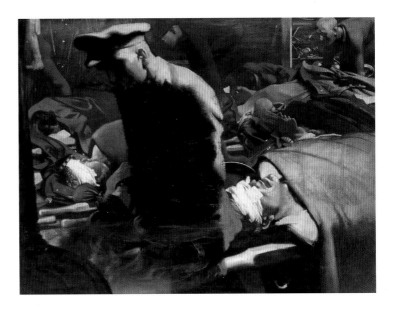

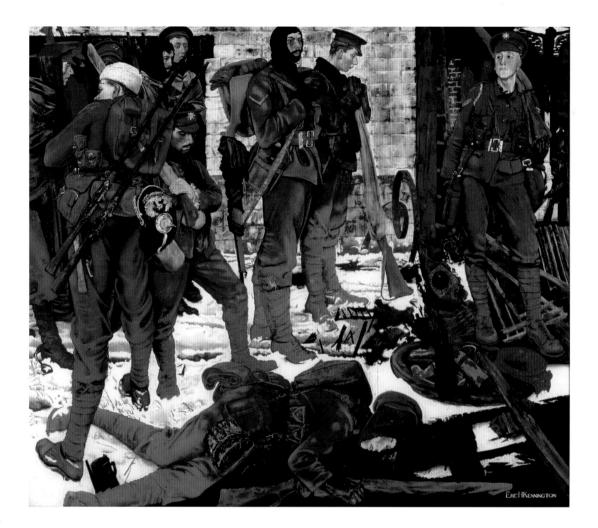

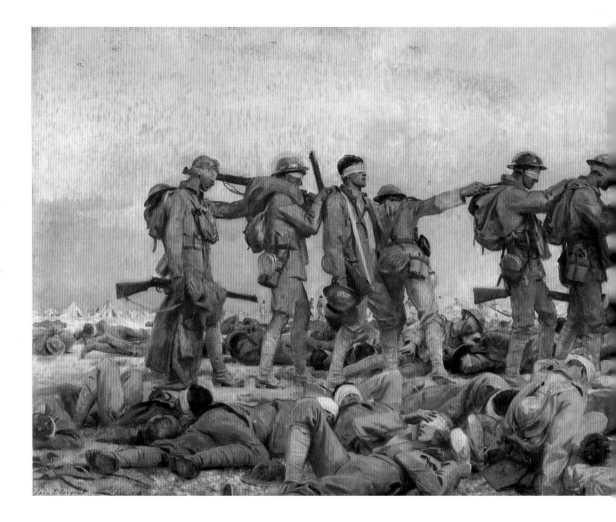

John Singer Sargent RA

Gassed, 1919

oil on canvas, 231 x 611.1 cm

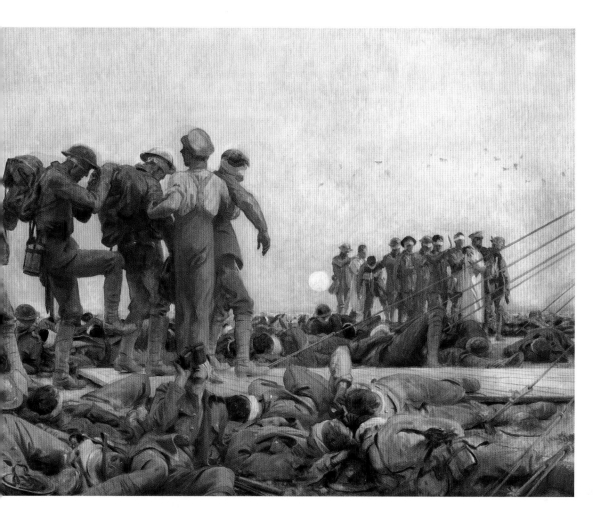

Sargent was the leading society painter of the day, and this painting is in stark contrast to his images of ease, wealth and respect. He was commissioned to contribute the central painting for the Hall of Remembrance and was given the theme of 'Anglo-American co-operation'. Unable to find suitable subject matter, he chose this scene instead, the aftermath of a mustard gas attack on the Western Front in August 1918, which he witnessed during a short visit to the front with the artist Henry Tonks. Mustard gas was an indiscriminate weapon causing widespread injury and burns as well as temporarily affecting the eyes.

The canvas is lightly painted with great skill. The overall impression is of loss and suffering, emphasised by the expressions of the men standing in line, their uneasy progress and the improvised medical dressings. In contrast, the football players in the background are physically and visually co-ordinated and have full kit.

Sir John Lavery RA, RSA

Lady Henry's Crêche, Woolwich, 1919

oil on canvas, 63.5 x 76.2 cm
Gift of Lady Henry, 1920

Lady Henry – Julia – was the wife of Sir Charles Solomon Henry, Liberal MP for Wellington in Shropshire. Lady Henry probably funded some of the costs for the building and running of the nursery herself together with subsidies from the Ministry of Munitions. The nursery opened in May 1917 and closed in March 1920 when Lady Henry presented it to the London County Council in memory of her only son, who had been killed during the war. Lavery, a successful society painter, was over military age and prevented from joining the Artists' Rifles, despite successive attempts. He was appointed an official war artist in 1917, but following a car crash in London, he remained in Britain, painting home front subjects.

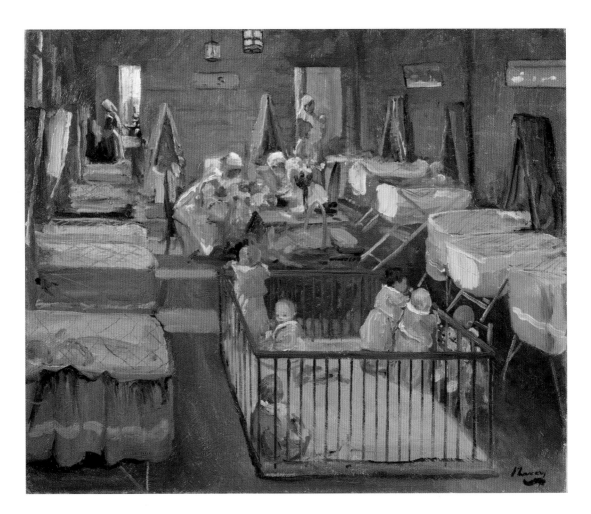

J Hodgson Lobley

The Queen's Hospital for Facial Injuries, Frognal, Sidcup: The Toy-makers' Shop, c.1918

oil on canvas, 45 x 60.7 cm
Gift of the British Red Cross Society and Order of St John of Jerusalem, 1919

The Queen's Hospital, Sidcup, opened in 1917 as a result of the flood of casualties from the Somme, was the First World War's major centre for maxillofacial and plastic surgery. Occupational therapy was an integral part of the rehabilitation treatment; men required things to do to fill the long days and weeks between operations and were also trained for life outside. Toys made at Sidcup were advertised by the London *Evening Standard* and were judged to be of very fine quality. There is an disturbing relationship between the stuffed monkey and the men, whose faces have been rendered expressionless by surgery or by masks.

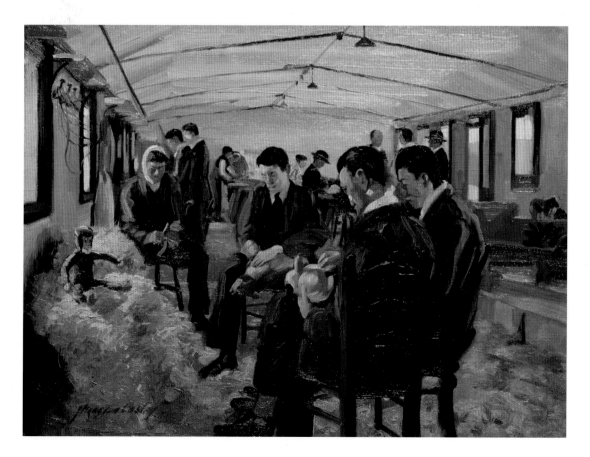

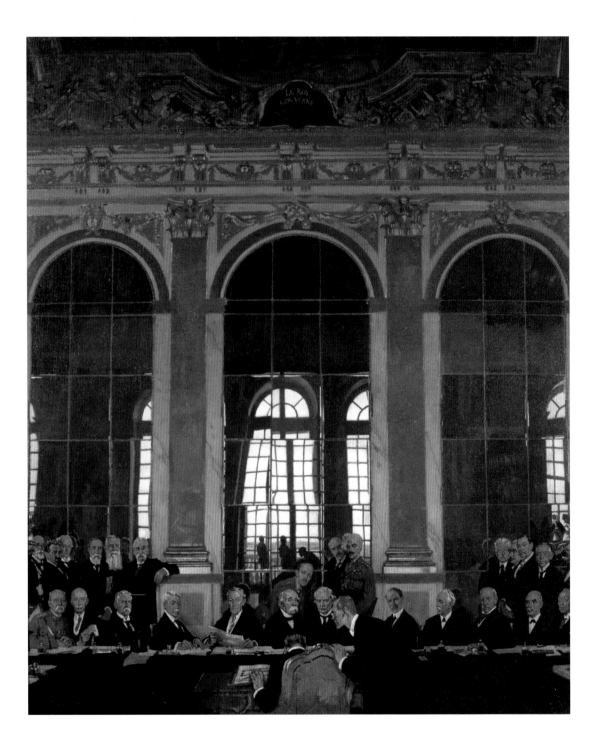

Sir William Orpen RA

The Signing of Peace in the Hall of Mirrors, Versailles, 28th June 1919, 1919

oil on canvas, 152.4 x 127 cm

To the Unknown British Soldier in France, 1921–28

oil on canvas, 154.2 x 128.9 cm
Presented by the artist in memory of Earl Haig, 1928

The Paris Peace Conference in 1919 resulted in the Treaty of Versailles. This is the moment of resolution for the Conference, when the leading Allied statesmen were able to demonstrate their determination and unity as the treaty was signed. The setting is the dazzling Hall of Mirrors at Versailles, built by Louis XIV as a demonstration of his power and majesty. The mirrors break up the well-ordered ceremony, and the architecture reduces the statesmen to a footnote. Above their heads reads the legend 'Le Roy Gouverne par lui même' (The King governs alone), an ironic reference to the Conference's endless squabbling.

Orpen was employed in 1919 to record the Peace Conference in three paintings; at £3,000, it was one of the most costly commissions of the war. To the Unknown British Soldier in France (above) was to be the final work. He had completed 30 portraits before taking the radical decision to paint over the politicians and military leaders and replace them with the flag-draped coffin. Orpen also added two semi-nude soldiers guarding the tomb and two cherubs above: 'After all the negotiations and discussions, the Armistice and Peace, the only tangible result is the ragged unemployed soldier and the Dead'. A number of the original portraits, along with the soldiers and cherubs, are still just visible.

The painting caused controversy when it was first exhibited at the Royal Academy in 1923, and the Imperial War Museum only accepted it after these figures were removed. Orpen eventually donated the canvas to the museum in memory of Earl Haig, 'one of the best friends I ever had'.

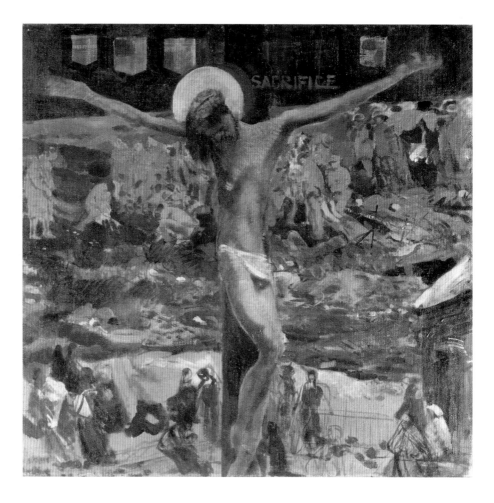

Sir Charles Sims RA

Sacrifice: Study for the painting in Ottawa, 1918

oil on canvas, 76 x 78 cm

Charles Sims's work was influenced by his spiritual and mystical ideas. His reaction to the First World War was profound, especially after his eldest son was killed in 1915. This was a blow from which he never recovered, and he committed suicide in 1928. *Sacrifice* draws explicitly on Christian imagery. The scene is dissected by a large crucifix. Beneath it are sketchy figures that occupy the middle ground of the painting. In the finished picture, held by the Canadian War Museum in Ottawa, they turn into the mourning figures of the parents and children of the fallen and wounded. This is one of the Canadian War Memorial paintings held by the War Museum and the National Gallery of Canada, many of which are by British artists.

Charles Sargeant Jagger
MC, ARA

'Wipers' – Maquette for the Hoylake War Memorial, West Kirby, 1922

plaster and bronze powder finish, 47 x 42 x 15 cm

Jagger joined the Artists' Rifles before being commissioned in the Worcestershire Regiment in 1915, serving in Gallipoli and on the Western Front. In 1918, he was approached by the Ministry of Information for the proposed Hall of Remembrance. Although this assignment did not come to fruition, he was subsequently engaged on a number of memorial projects, including the Royal Artillery Memorial at Hyde Park Corner, typified by friezes and powerful, brooding figures.

The Hoylake and West Kirby War Memorial was unveiled on 16 December 1922.

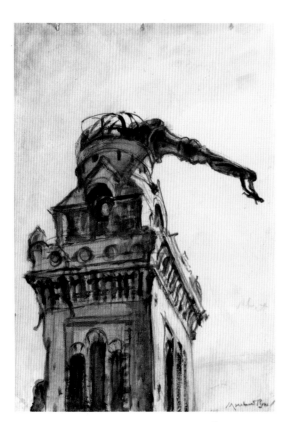

Sir Muirhead Bone

The Virgin of Albert, Notre Dame de Brebières, 1917

pencil, wash on paper, 35.8 x 25 cm
Gift of the artist, 1919

Prior to the war, the church tower was topped by a golden figure of the Virgin Mary holding aloft the infant Jesus. Hit by a German shell, it was secured in position by French engineers. In this precarious state, where faith, tradition and peace (a local legend said that when the Virgin fell the war would end) are all held in the balance, the tower became a popular image for many artists.

IMAGE LIST

All images © IWM unless otherwise stated.

1. IWM ART 4485
 © The artist's estate
3. IWM ART 1656
4. IWM ART 4485 (detail)
 © The artist's estate
9. IWM ART 16102
 © The estate of John Copley
10. IWM ART 4031
11. IWM ART 1210
12. IWM ART 1184
13. IWM ART 2759
14. IWM ART 519
15. IWM ART 516
16. IWM ART 3138
17. IWM ART 2746
18. IWM ART 2268
19. IWM ART 1471
 © The estate of
 Harold Sandys Williamson
20. IWM ART 2955
21. IWM ART 1656
22. IWM ART 2001
23. IWM ART 2243
24. IWM ART 2747
26. IWM ART 2708
27. IWM ART 5932
 © The Bridgeman Art Library/
 The Estate of Percy
 Wyndham Lewis
28. IWM ART 15122
 © The estate of David Jones
29. IWM ART 1145
30. IWM ART 200, IWM ART 5219
 © The Bridgeman Art Library/
 The Estate of CRW Nevinson
32. IWM ART 15594
 © The Estate of John David
 Roberts. By permission of the
 William Roberts Society
33. IWM ART 17435
 © The Estate of John David
 Roberts. By permission of the
 William Roberts Society
34. IWM ART 2242
36. IWM ART 2473
37. IWM ART 2380
38. IWM ART 2751
 © Tate, London, 2013
39. IWM ART 2953
40. IWM ART 4663
41. IWM ART 4655
42. IWM ART 2440
43. IWM ART 1146
44. IWM ART 1918
45. IWM ART 2705
46. IWM ART 2271, IWM ART 2852
47. IWM ART 4434
48. IWM ART 935
50. IWM ART 5728
 © The Fergusson Gallery,
 Perth and Kinross Council
51. IWM ART 5527
 © The estate of Edward
 Wadsworth. All rights reserved,
 DACS 2013
52. IWM ART 2237
53. IWM ART 1360
 © The Royal Society of
 Marine Artists
54. IWM ART 4744
55. IWM ART 15661
56. IWM ART 1460
58. IWM ART 3084
59. IWM ART 3756
60. IWM ART 2856
61. IWM ART 4438
62. IWM ART 5581
63. IWM ART 6484
64. IWM ART 2042
 © The artist's family

Caption texts by Sara Bevan, Matthew Brosnan, Kathleen Palmer, Ulrike Smalley, Richard Slocombe, Roger Tolson, Angela Weight and Jenny Wood.